.

v

alife of life

"A life spent making mistakes is not only more honorable, but more useful than a life spent doing nothing." — George **Bernard Shaw**

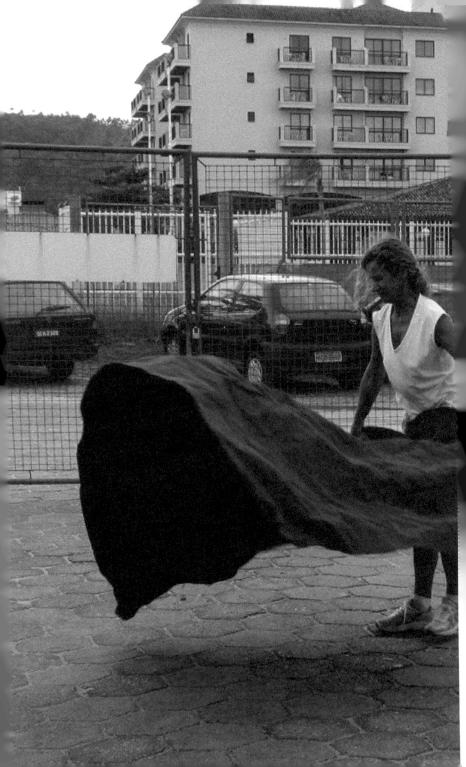

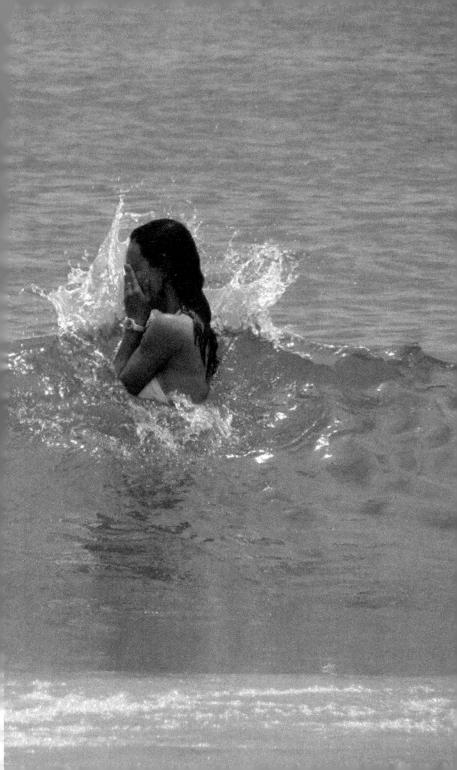

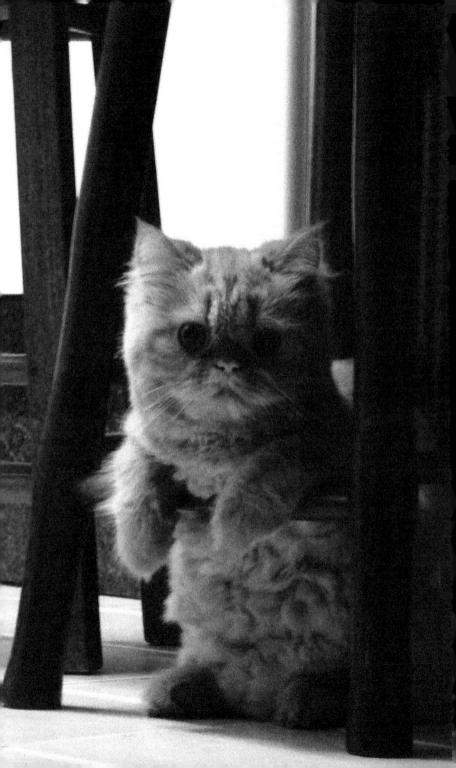

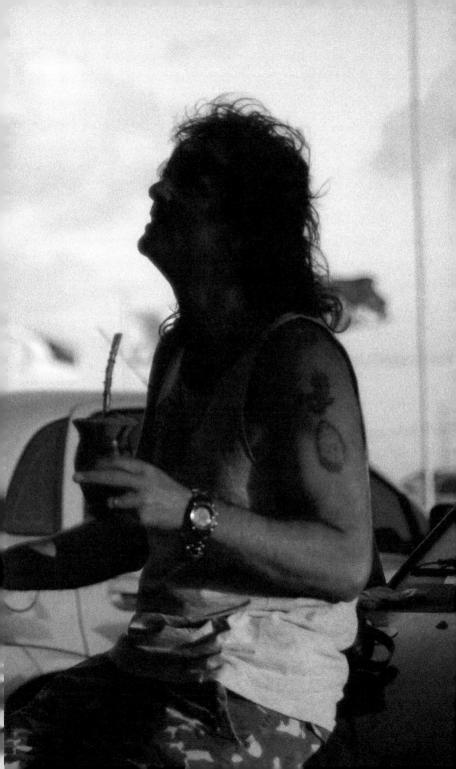

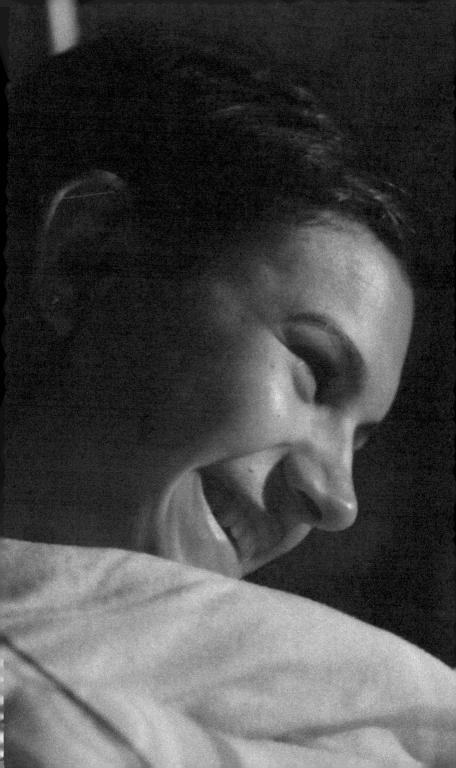

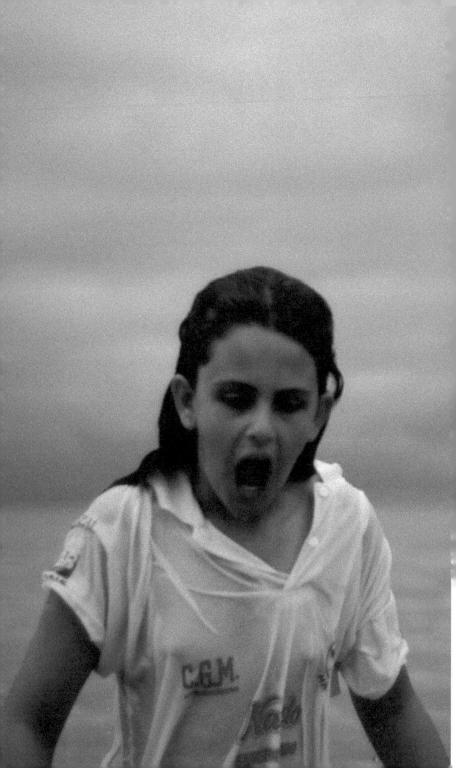

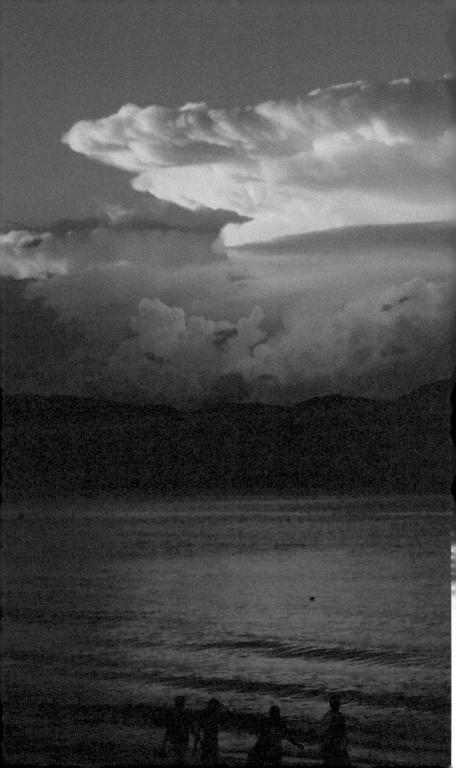

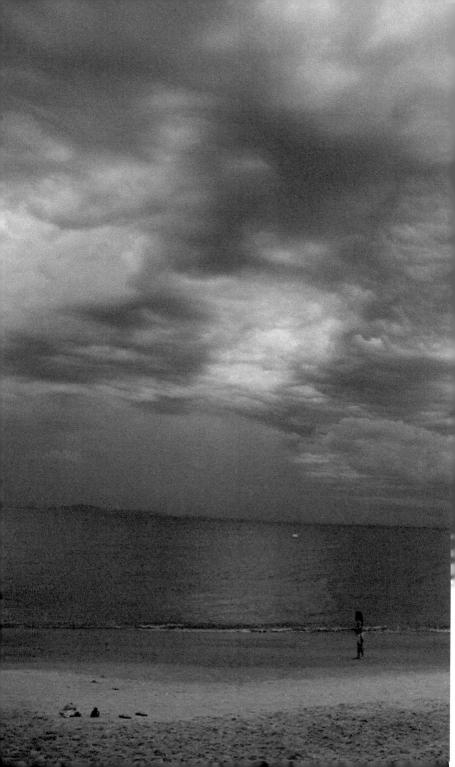

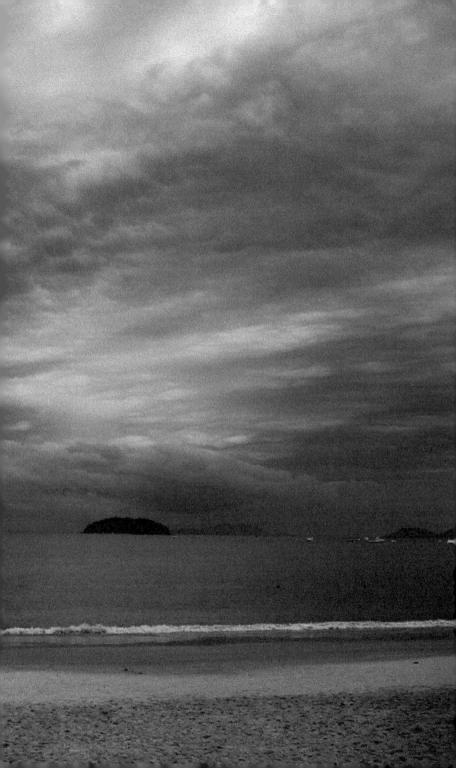

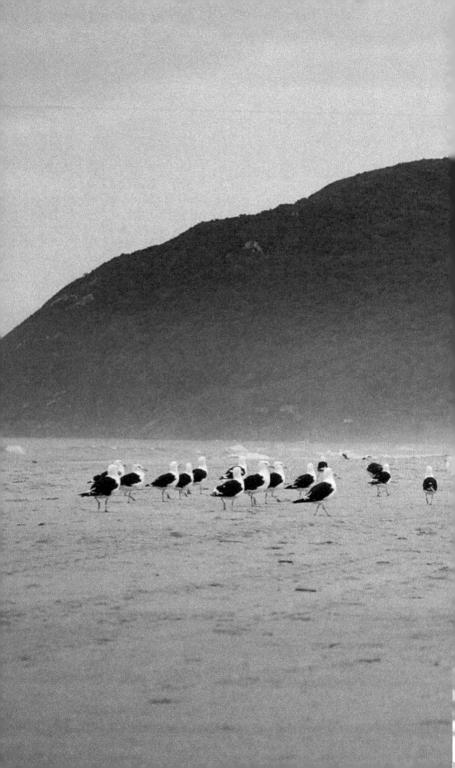

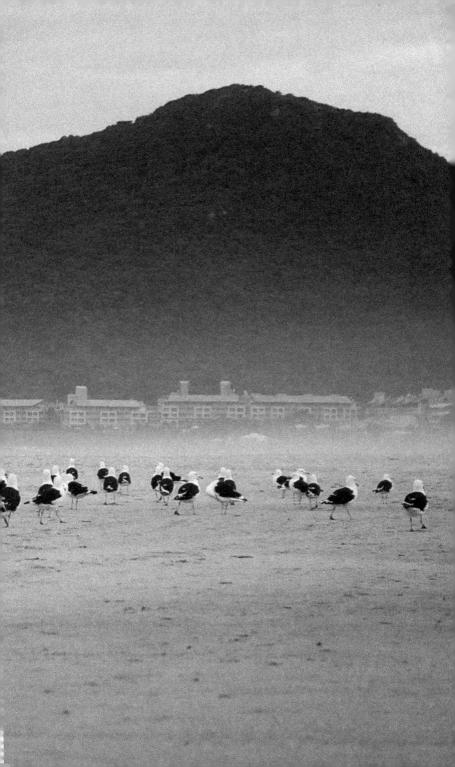

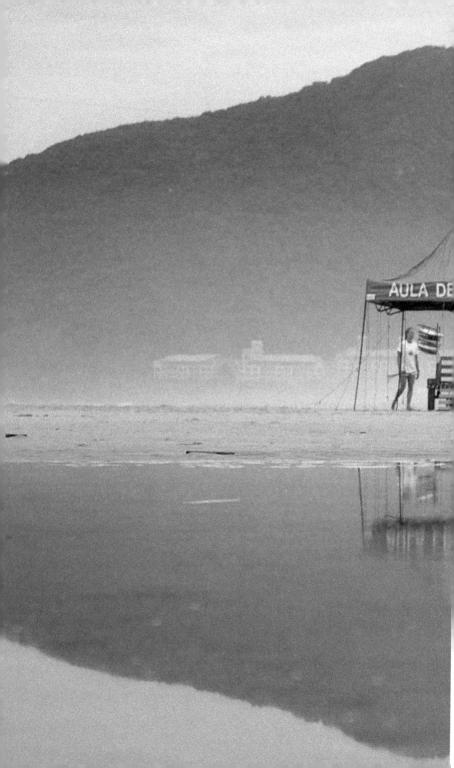

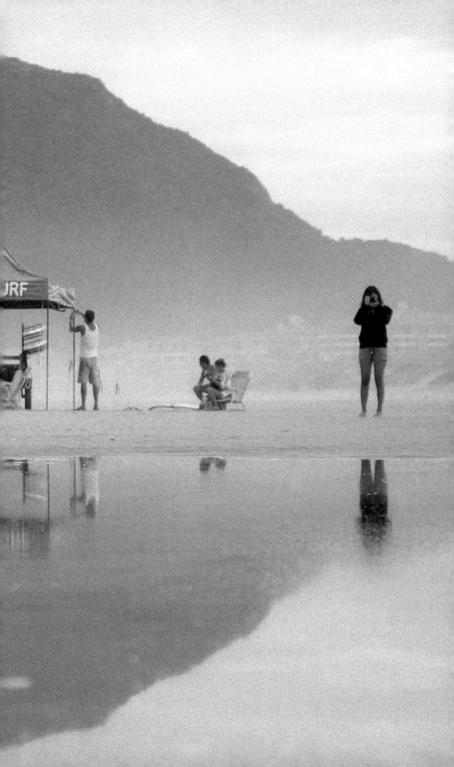

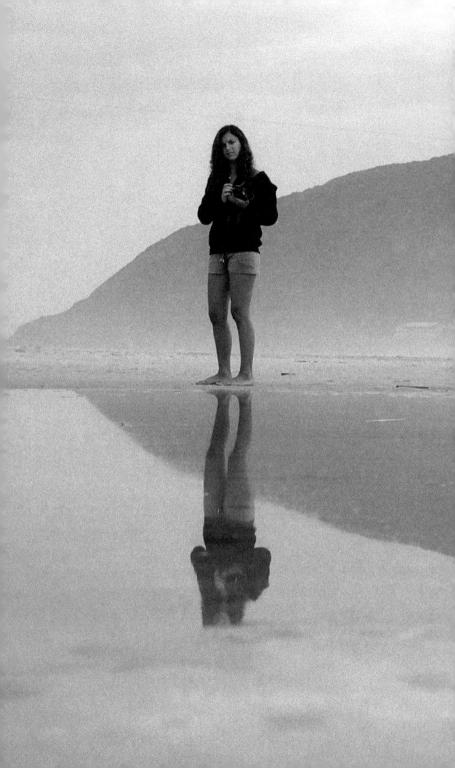

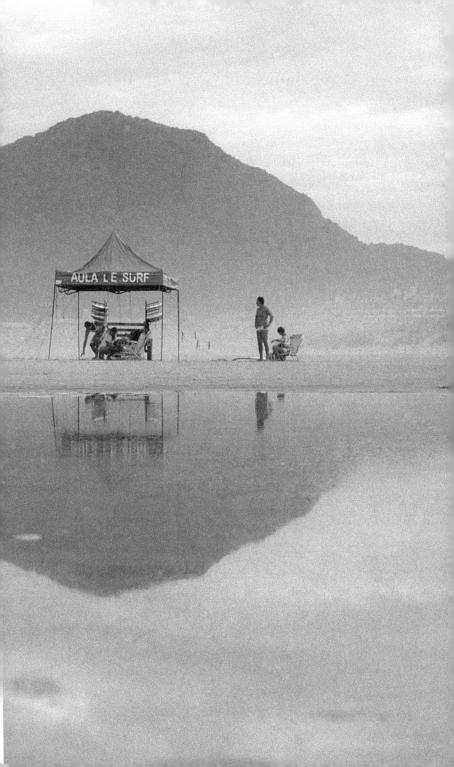

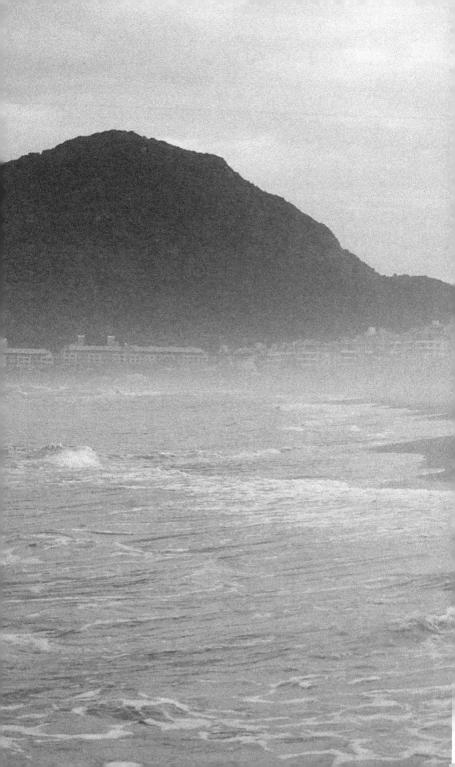

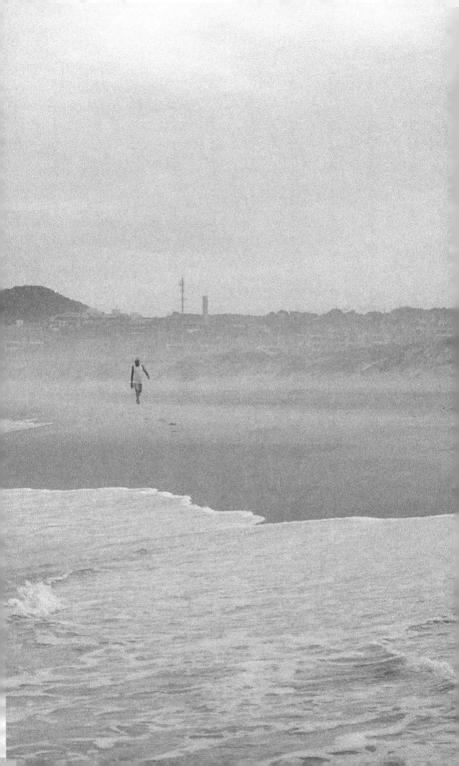

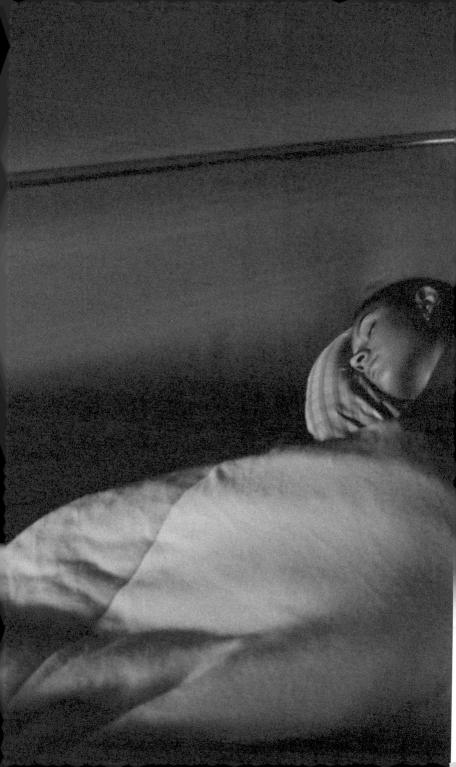

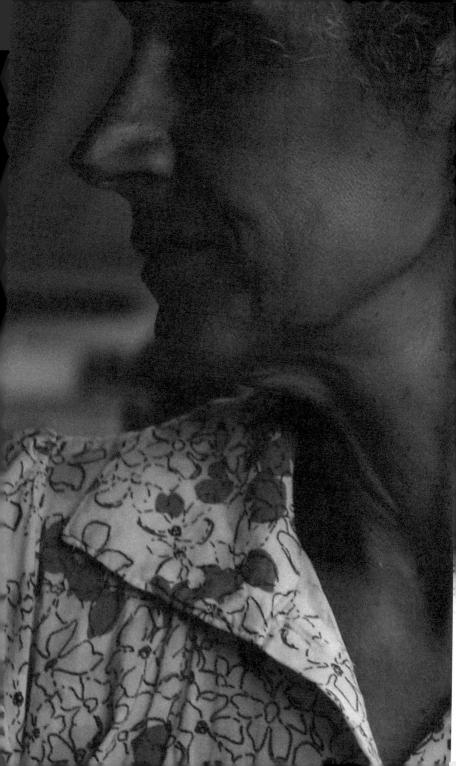

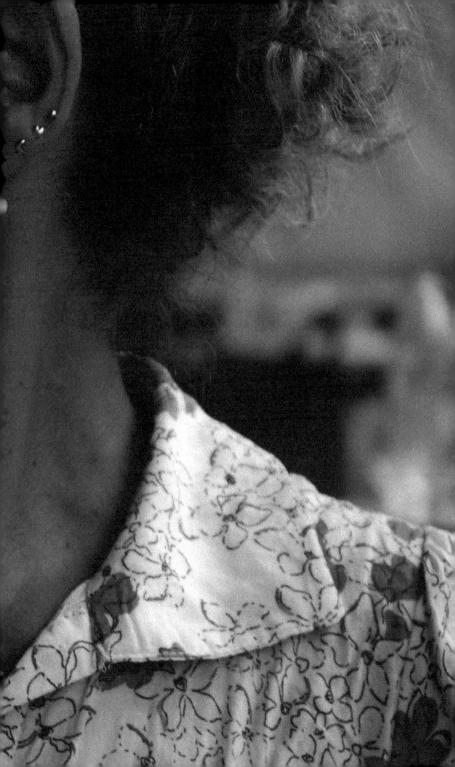

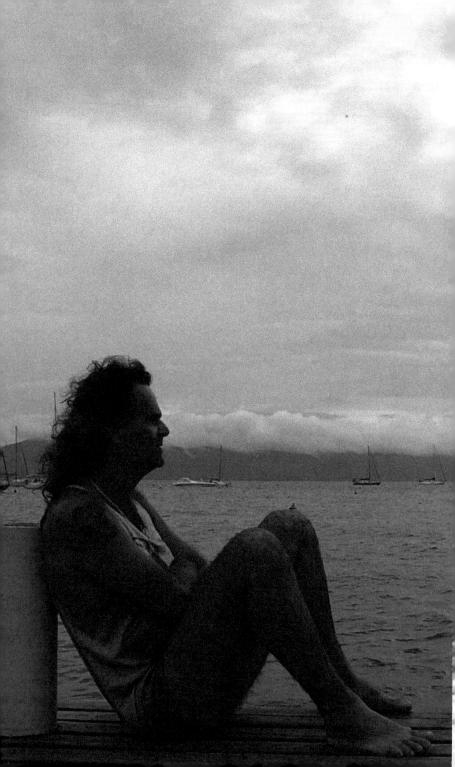

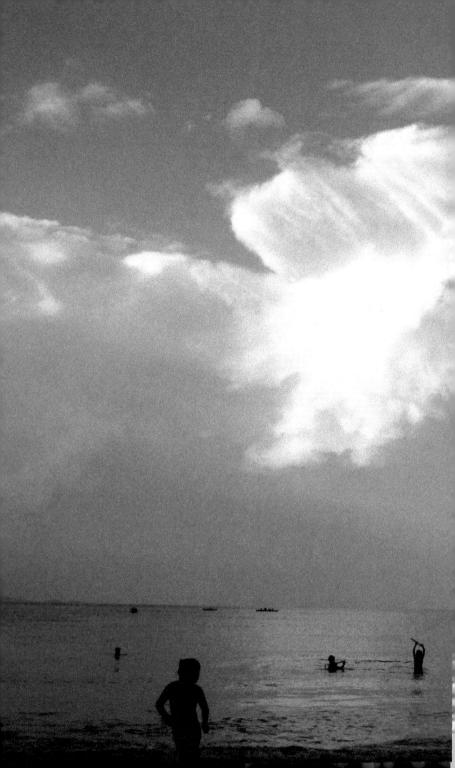

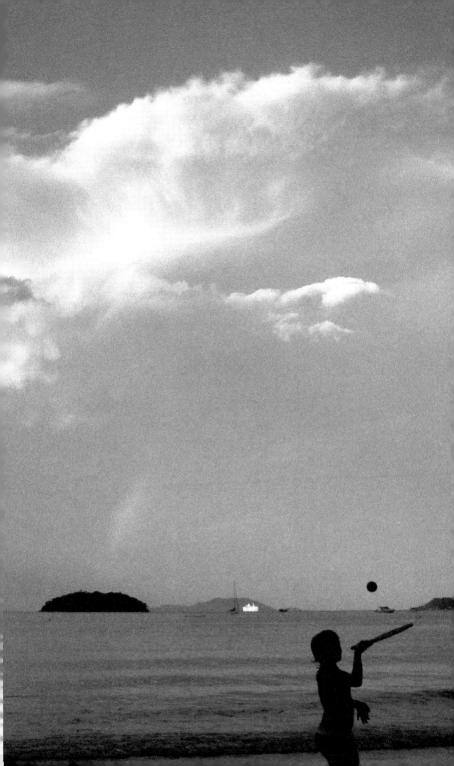

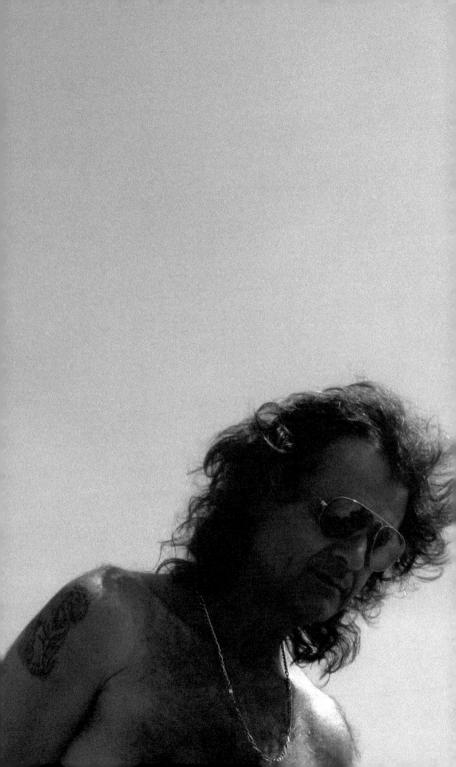

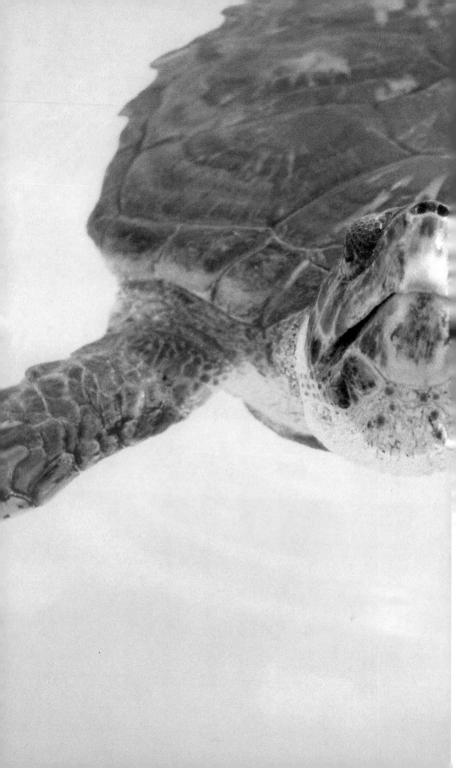

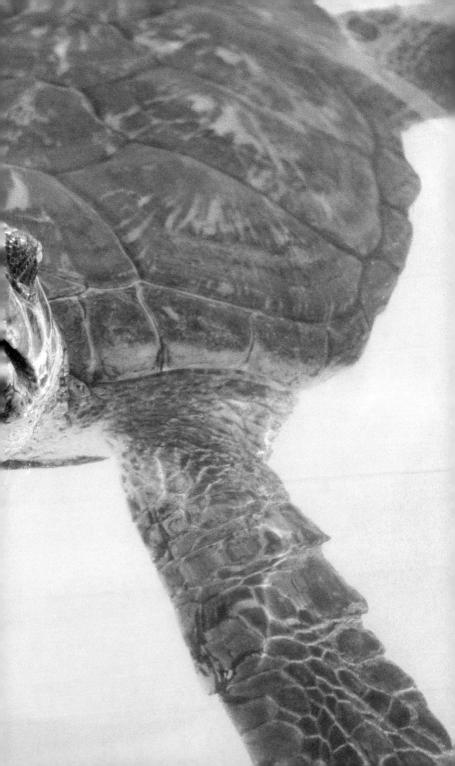